See Scotland by Train

National Museums Scotland

See Scotland by Train

National Museum of Scotland
Chambers Street
Edinburgh EH1 1JF

16 March to 24 June 2012

www.nms.ac.uk

Publication:

First published in 2012 by
NMS Enterprises Limited – Publishing
a division of NMS Enterprises Limited
National Museums Scotland
Chambers Street, Edinburgh EH1 1JF
www.nms.ac.uk

**British Library Cataloguing in Publication
Data**
A catalogue record for this book
is available from the British Library.

ISBN: 978 1 905267 72 9

Cover design: Mark Blackadder
Cover image: Coronation and Coronation
 Scot, Bryan de Grineau, 1938; Photography
 by National Museums Scotland; © NRM
 Pictorial Collection/Science & Society
 Picture Library
Title Page: An 1842 cast-iron milepost
 (National Museums Scotland)
Page 4: Willie Stanners, engine driver on the
 footplate of *Merlin*, 1963/64 (National
 Museums Scotland)

Publication format:
 NMS Enterprises Limited – Publishing
Printed and bound in the United Kingdom by
 ARC Printing Ltd, West Calder

Published by National Museums Scotland as
one of a number of titles based on museum
scholarship and partnership.

For a full listing of NMS Enterprises Limited –
Publishing titles and related merchandise:

www.nms.ac.uk/books

Contents

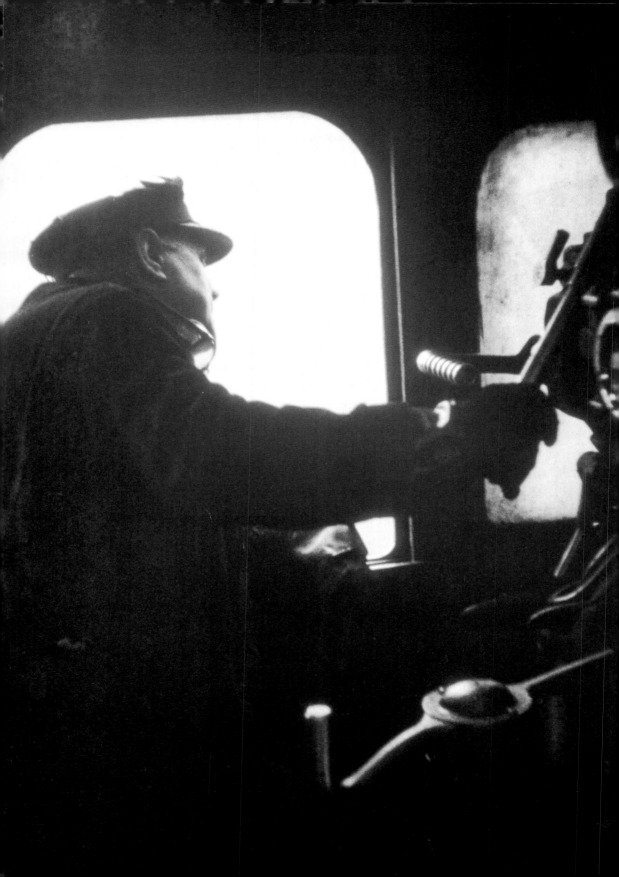

From a Railway Carriage

Faster than fairies, faster than witches,
Bridges and houses, hedges and ditches;
And charging along like troops in a battle
All through the meadows the horses and cattle:
All of the sights of the hill and the plain
Fly as thick as driving rain;
And ever again, in the wink of an eye,
Painted stations whistle by.
Here is a child who clambers and scrambles,
All by himself and gathering brambles;
Here is a tramp who stands and gazes;
And there is the green for stringing the daisies!
Here is a cart run away in the road
Lumping along with man and load;
And here is a mill, and there is a river:
Each a glimpse and gone for ever!

ROBERT LOUIS STEVENSON (1850–1894)

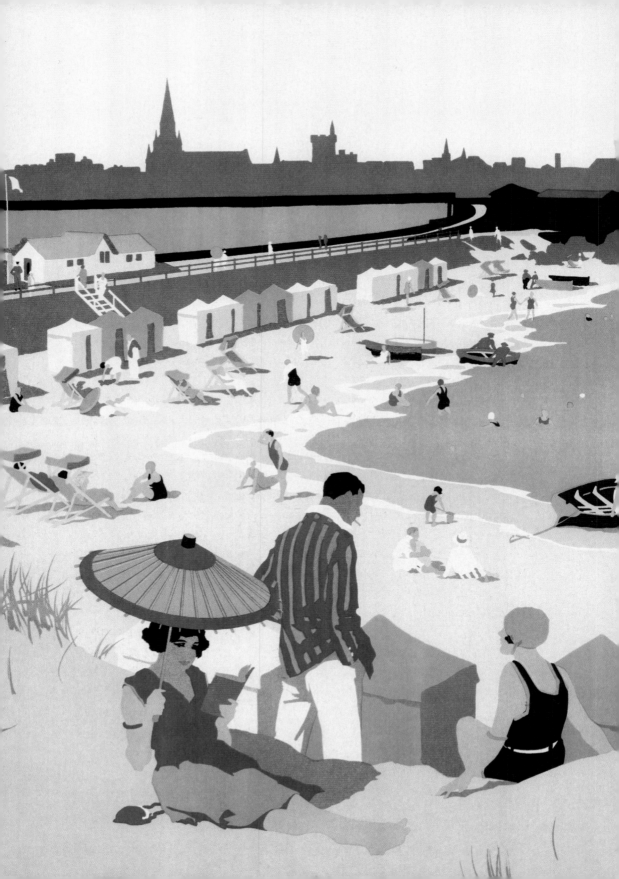

Foreword

The growth in rail travel from the middle years of the 19th century coincided with developments in printing which permitted large full-colour advertising posters to be produced cheaply for use by railway companies. At first the posters conveyed what, to us, seems a muddle of information, graphics and illustrations. However, from the early decades of the 20th century, poster design matured and a number of noted artists exploited its possibilities with clear and striking images. The rising number of tourists to Scotland over this period was due in large part to their efforts, which presented a frequently romantic view of the attractions of the Scottish landscape and heritage to rail travellers all over the United Kingdom.

In National Museums Scotland we are keen not only to represent the history and technology of rail travel in Scotland, but also the ways in which this technology was represented to its users. We have now collected a number of key examples of rail travel posters encompassing a range of originating companies, graphic styles and subject matter. A striking feature of the rail poster is the longevity of the medium, and we have examples dating from the early 20th century to the present. We have augmented these with items from the National Railway Museum in York and are very grateful for their support. All the posters evoke the design fashions of their time – but they also invite closer examination of the ways that artists have striven to sell speed, comfort and a taste of Scotland. We hope that you enjoy the exhibition, and this catalogue which accompanies it.

Jane Carmichael

Director of Collections

National Museums Scotland

Fraserburgh (detail)

H. G. Gawthorn, 1934

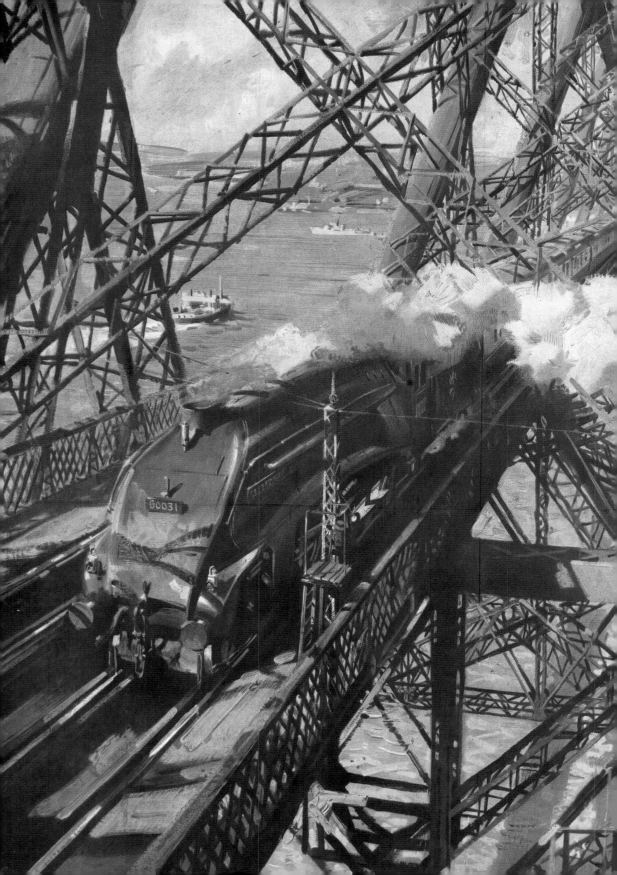

See Scotland by Train

It may have been Queen Victoria's love of the Highlands that made Scotland such a popular tourist destination from the late 19th century, but it was the coming of the railways that opened up many previously inaccessible areas to these tourists. And nothing romanticised the image of the Highlands more than the railway poster.

Designed to attract people to travel, the simple advertising poster grew to become a thing of beauty created by many significant artists of the day. The posters included in this exhibition catalogue celebrate that art, the Scottish landscape, and the railways that ran through it.

Scotland for your Holidays (detail)
Terence Cuneo, 1952

Photography by National Museums Scotland
© NRM Pictorial Collection/Science & Society
Picture Library

Above: Train at Caledonian station, Princes Street, Edinburgh, 1900

National Museums Scotland

Opposite: Locomotive model

This finely engineered steam powered model, made in 1883, represents a Great Northern Railway locomotive that would have been in use at the time when the first railway advertising posters were appearing.

National Museums Scotland

Beginnings and the Golden Age of Rail Travel

The railway advertising poster can trace its origins to the mid-19th century notices that intimated route timetables and changes to rail services. By the 1890s these simple notices were being embellished with attractive artwork, as the railways competed with each other for passengers. However, every small railway company had its own style and their posters were usually cluttered and confusing.

By the early 20th century, many small companies had amalgamated or been taken over by the larger ones, such as North British or Caledonian. In 1923 all the railway companies in Britain were grouped into four large companies. Scotland was split between London and North Eastern Railway (LNER) and London Midland and Scottish (LMS). This grouping signalled the start of a golden age for rail travel.

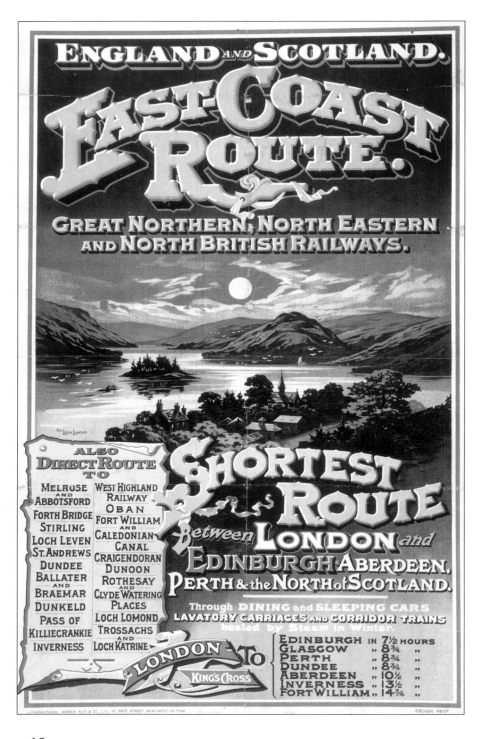

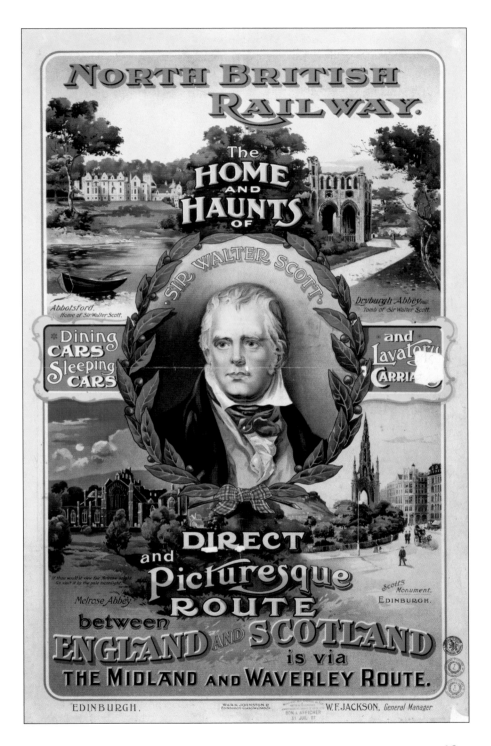

Page 12: East Coast Route

Anonymous, 1895

New methods of printing in the late 19th century allowed colourful images to be produced cheaply. This romantic view of Scotland was an example of joint marketing by the three companies that operated the East Coast route from London to Edinburgh and beyond.

Photography by National Museums Scotland
© NRM Pictorial Collection/Science & Society Picture Library

Page 13: Direct Route between England and Scotland

Anonymous, 1907

North British Railway worked in partnership with Midland Railway to provide a service from London to Edinburgh via Carlisle and the Waverley Route through the Borders. The images on the poster are of historic places to visit by train that were associated with the writer Sir Walter Scott.

Photography by National Museums Scotland
© NRM Pictorial Collection/Science & Society Picture Library

Opposite, above: East Coast Route – A Contrast

Anonymous, 1914

This poster is an early example of using humour to advertise rail travel on the London to Edinburgh route. Using the style of a coaching era bill post, it compares travel in 1706 from York with rail travel in 1914. This poster would not have had the same impact as those using attractive views that were becoming popular.

Photography by National Museums Scotland
© NRM Pictorial Collection/Science & Society Picture Library

Below: East Coast Route Poster at Gullane station, East Lothian, 1914

William Fulton Jackson, photographer

This North British poster was spotted by William Fulton Jackson, a keen amateur photographer and a senior manager of the North British Railway. The poster was pinned to a wooden door at Gullane station.

© Glasgow University Archives & Business Records Centre. Licensor www.scran.ac.uk.

EAST COAST ROUTE
A CONTRAST

YORK Four Days Stage-Coach.

Begins on Friday the 12th of April 1706.

ALL that are defirous to pafs from London to York or from York to London or any other Place on that Road. Let them Repair to the Black Swan in Holbourn in London and to the Black Swan in Coney ftreet in York

At both which Places they may be received in a Stage Coach every Monday. Wednefday and Friday. which performs the whole Journey in Four Days (if God permits) And fets forth at Five in the Morning

And returns from York to Stamford in two days and from Stamford by Huntingdon to London in two days more. And the like Stages on their return.

Allowing each Paffenger 14lb weight and all above 3ᵈ a Pound.

Performed By — Benjamin Kingman / Henry Harrifon / Walter Baynes

Alfo this gives Notice that Newcaftle Stage Coach fets out from York every Monday. and Friday. and from Newcaftle every Monday. and Friday.

Rec'd in pl 05 00 0 of Mr Boddington fungtk for Monday the 3 of June 1706

YORK COACHING DAYS
Fac-simile of the Coaching Notice in **1706**

LONDON and EDINBURGH Daily train Service

ALL that are defirous to pafs from London to Edinburgh or from Edinburgh to London or any other Place on that Road: Let them repair to the King's Crofs Station of the Great Northern Railway in London, and the Waverley Station of the North British Railway in Edinburgh.

At both which places they may be received in well appointed exprefs trains. With Luncheon and Dining Cars in the Day Time and Sleeping Cars at Night. which perform the whole Journey in SEVEN and THREE QUARTER HOURS. And fet forth at Convenient times in the Morning and in the Afternoon and at Night.

And run from London to York in Three Hours and Thirty Five Minutes. And from York to Edinburgh in Four Hours and Ten Minutes more. And the like Stages on their return.

Performed By — Great Northern Railway / North Eastern Railway / North British Railway

1914

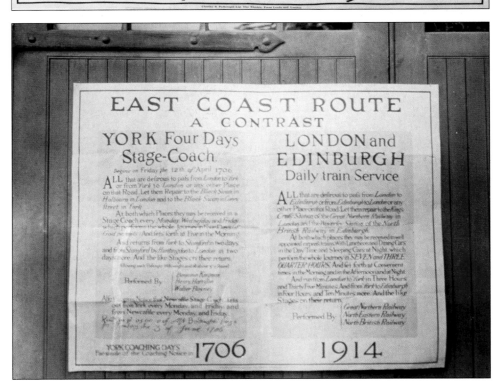

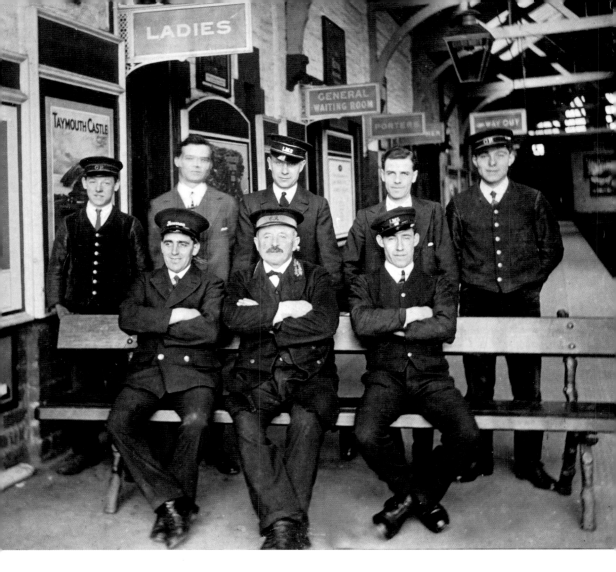

Above: Railway staff, Grangemouth station, 1924

Photographer unknown

Railway workers pose with the Station Master in the uniforms of the Caledonian and London Midland and Scottish railways, on the platform of Grangemouth station. The booking clerks are in suits. Both Grangemouth station and the port of Grangemouth were operated by the Caledonian Railway until it was absorbed by LMS in 1923.

Opposite: Signal lamp, Duns, Berwickshire 1919

Bulpitt and Sons Ltd, Birmingham, maker

Lamps have always been an essential part of railways. They have been used for many purposes from lighting stations to being carried on locomotives and from illuminating carriages to showing the colour of a signal. This signal lamp was used by the North British Railway.

National Museums Scotland

The Big Four

Throughout the 19th century hundreds of small companies were formed to build railway lines throughout Britain. By the 1920s these had been distilled down to about 25, which the government decided should be amalgamated into four large companies under the Railways Act 1921.

The new railways came into being on 1 January 1923, with Southern and Great Western operating in the south of England. London Midland and Scottish covered the west of Britain, and London and North Eastern Railway the east side.

Initially there was great rivalry between the companies, but during the 1920s and 1930s, LMS and LNER formed close ties, with frequent joint marketing of services.

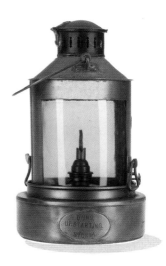

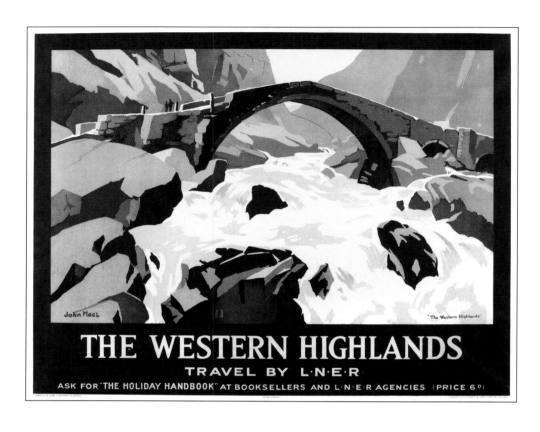

The Western Highlands, John Mace, 1930. Text on poster: "THE WESTERN HIGHLANDS / TRAVEL BY L·N·E·R / ASK FOR "THE HOLIDAY HANDBOOK" AT BOOKSELLERS AND L·N·E·R AGENCIES (PRICE 6ᴰ)"

Above: The Western Highlands

John Mace, 1930

Although the location of the bridge in this dramatic LNER poster is not known, it is typical of many locations in the Scottish Highlands. The stark use of a muted colour pallet is as eye-catching as the many full colour images used at this time. Mace was a renowned landscape painter and war artist.

Photography by National Museums Scotland
© NRM Pictorial Collection/Science & Society Picture Library

Opposite: Fraserburgh

H. G. Gawthorn, 1934

This poster from LNER paints an idyllic picture of Fraserburgh in the 1930s and was designed to attract visitors to holiday in the town. The east coast of Scotland can sometimes suffer from cold winds and sea mist, so alternatives to sunbathing are being promoted.

Photography by National Museums Scotland
© NRM Pictorial Collection/Science & Society Picture Library

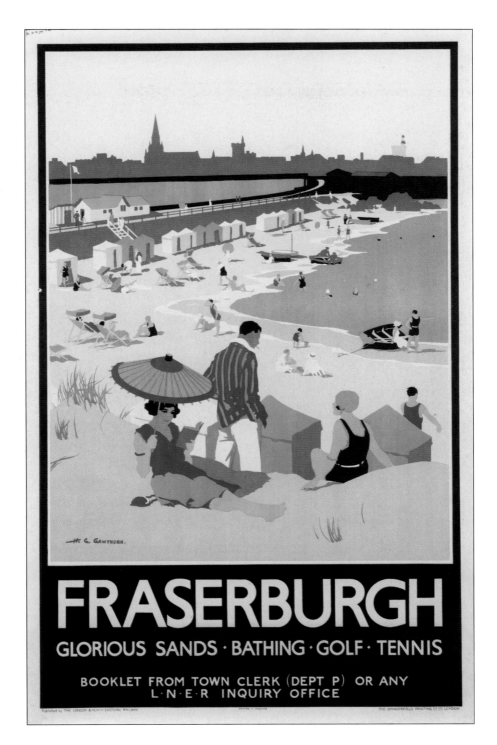

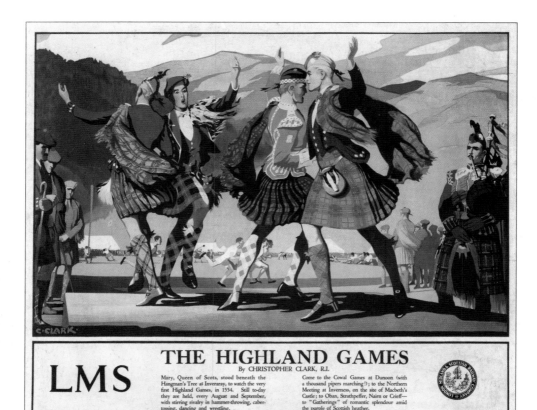

Above and detail opposite:
The Highland Games

Christopher Clark, 1930s

By the time this poster was issued in the late 1930s, LMS was working more closely with the old rival LNER. This poster presents perhaps a clichéd image of Scotland with Highland dancers and a piper against a mountainous backdrop.

Photography by National Museums Scotland
© NRM Pictorial Collection/Science & Society Picture Library

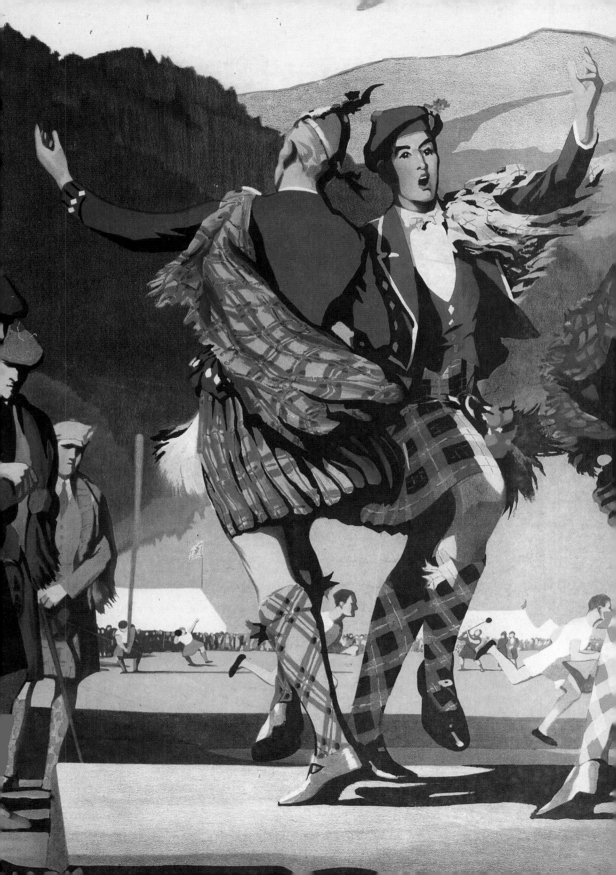

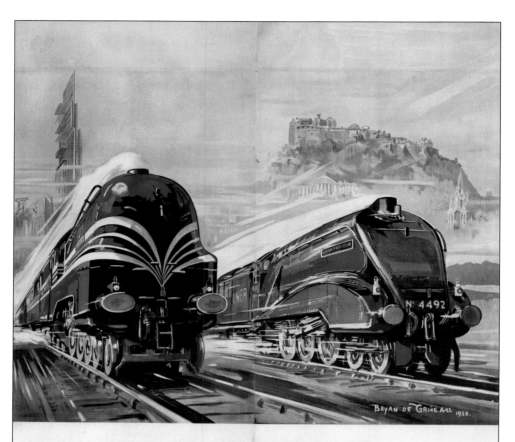

GLASGOW

by

"THE CORONATION SCOT"

Euston - Glasgow in 6½ hours

MONDAYS TO FRIDAYS

EUSTON	dep.	1-30 p.m.
GLASGOW (CENTRAL)	arr.	8-0 p.m.
GLASGOW (CENTRAL)	dep.	1-30 p.m.
EUSTON	arr.	8-0 p.m.

LONDON MIDLAND AND SCOTTISH RAILWAY

EDINBURGH

by

"THE CORONATION"

King's Cross - Edinburgh in 6 hours

MONDAYS TO FRIDAYS

KING'S CROSS	dep.	4-0 p.m.
EDINBURGH (WAVERLEY)	arr.	10-0 p.m.
EDINBURGH (WAVERLEY)	dep.	4-30 p.m.
KING'S CROSS	arr.	10-30 p.m.

LONDON AND NORTH EASTERN RAILWAY

Coronation and Coronation Scot

This poster balances a striking image with detailed information on the England to Scotland services. It seeks to contrast the styles of Scotland's two major cities. The modernity of Glasgow is shown by the sleek design of the Coronation Scot locomotive, as well as by the shipyards and Empire Exhibition tower. The more conservatively designed A4 locomotive appears in front of Edinburgh Castle, the Scott Monument and National Galleries, representing the history and culture of Edinburgh.

Opposite: Coronation and Coronation Scot

Bryan de Grineau, 1938

Photography by National Museums Scotland
© NRM Pictorial Collection/Science & Society Picture Library

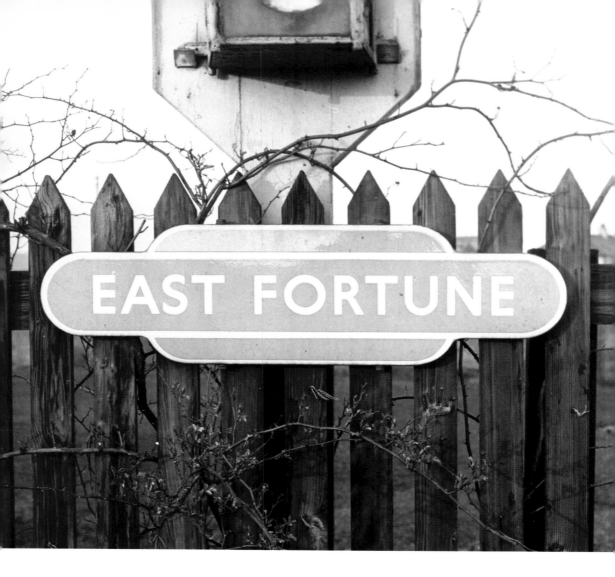

Above: East Fortune station, 1966

Photographer unknown

East Fortune was a station on the East Coast main line that opened in 1849 and closed in 1964. The station mainly served the adjoining airfield during both World Wars, as well as the sanatorium hospital. The airfield at East Fortune is now home to the National Museum of Flight.

© The Scotsman Publications Ltd.
Licensor www.scran.ac.uk.

Opposite: East Fortune station sign, 1948

National Museums Scotland

Nationalisation

During the 1930s, the four large railway companies began sharing advertising and working more closely together. Had the Second World War not broken out, it is possible that the LNER and LMS companies might have merged. After the war, the railways were worn out and the government intervened to nationalise the industry in 1948.

What emerged was the new British Railways. This was divided into regions, with the whole of Scotland being treated as one. A single corporate style was introduced and different regions assigned different colours. Scotland was given blue. An iconic logo, known as a totem, was used in advertising and station names signs. Poster design was now unified and many well-known artists – such as Terence Cuneo, Norman Wilkinson and Patrick McIntosh – continued to be used.

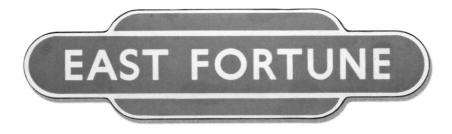

DUNOON
ON THE FIRTH OF CLYDE

For free Guide and list of accommodation apply to
the Secretary, Development Association, Dept. P.
Dunoon, Argyll.

Train and Steamer services from stations, offices and agencies

26

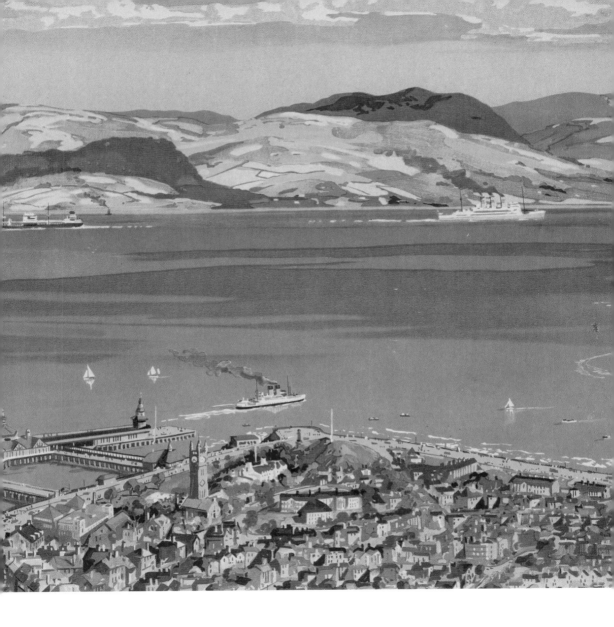

Opposite and detail above: Dunoon

Montague Black, 1950

The bird's-eye view design was popular both before and after the Second World War. Here the intention was to persuade tourists to travel by rail to Gourock and take the railway-owned Clyde Shipping Services ferry to the popular resort of Dunoon.

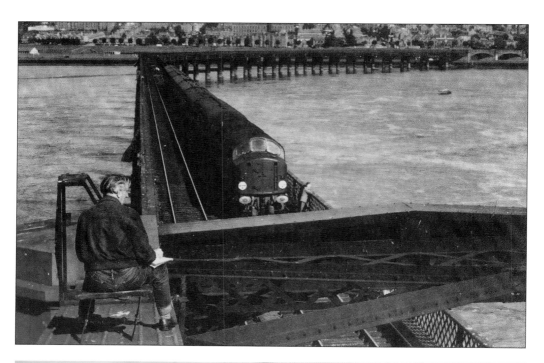

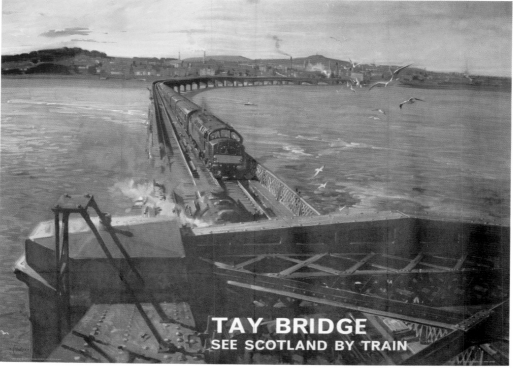

TAY BRIDGE
SEE SCOTLAND BY TRAIN

Cuneo on the Tay Bridge

Artist Terence Cuneo positioned himself on the exposed girder of the Tay Bridge in a strong wind while preparing his sketch. He noted afterwards that the wind made him dizzy and he felt like he was falling off the bridge. The diesel-hauled train was specially parked for the sketch, while the steam locomotive that is hinted at beneath the girder was painted in later.

Opposite, above: Photograph of Terence Cuneo sketching on the Tay Bridge, 1957

Courtesy of Carole Cuneo

Below: Tay Bridge – See Scotland by Train

Terence Cuneo, 1957

This poster is the final published version of Cuneo's artwork. From 1953, Cuneo adopted a mouse as his trademark, featuring them in all his railway paintings. You will find his mouse on one of the girders.

Photography by National Museums Scotland
© NRM Pictorial Collection/Science & Society Picture Library

See Scotland . . .

Aberdeen — Inverness diesel train near Forres

. . . with a

FREEDOM of SCOTLAND

TICKET issued on any day during the period 1st March — 31st October 1963. UNLIMITED RAIL TRAVEL for 7 or 14 consecutive days BETWEEN ANY STATIONS IN SCOTLAND (including Berwick-upon-Tweed and Carlisle) and on steamer services of the Caledonian Steam Packet Company Limited on the Firth of Clyde and Loch Lomond.

SILVER ticket
VALID FOR 7 DAYS

£6.6.0 SECOND CLASS (£9.9.0 FIRST CLASS)

Reduced rates for family travel

GOLD ticket
VALID FOR 14 DAYS

£10.10.0 SECOND CLASS (£15.15.0 FIRST CLASS)

Children 3 and under 14 years half the adult rate

Folder with full details at BRITISH RAILWAYS *stations and offices*

Published by British Railways (Scottish Region)

Printed by Jordison & Co Ltd London and Middlesbrough

30

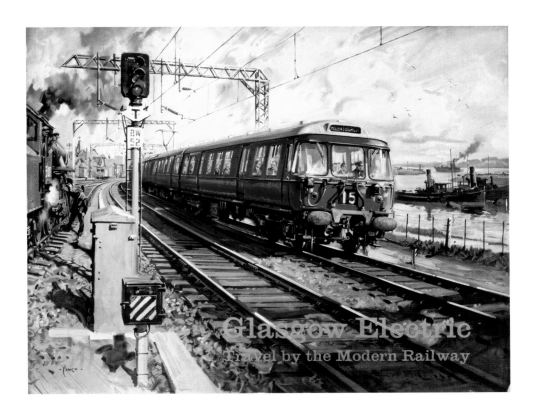

Opposite: Freedom of Scotland

Anonymous, 1963

This poster harks back to an early style with much of the space being taken up with fare information. The Highland scene would have caught the eye, although not to the same extent as the classic pre-war paintings. Tourists were encouraged to use the train to see Scotland for their holidays, purchasing tickets with unlimited travel for short periods.

Photography by National Museums Scotland
© NRM Pictorial Collection/Science & Society Picture Library

Above: Glasgow Electric

Terence Cuneo, 1960

The 1960s was a time of change on Britain's railways with the end of steam power. This poster is advertising the new electric service around Glasgow, soon to be known simply as the 'Blue Train'.

This scene near Helensburgh was another classic illustration from the prolific poster artist Terence Cuneo. The poster makes it clear that electric means modern travel, with a steam locomotive and a ship both billowing out black smoke. Cuneo's trademark mouse can again be seen.

© NRM Pictorial Collection/Science & Society Picture Library

31

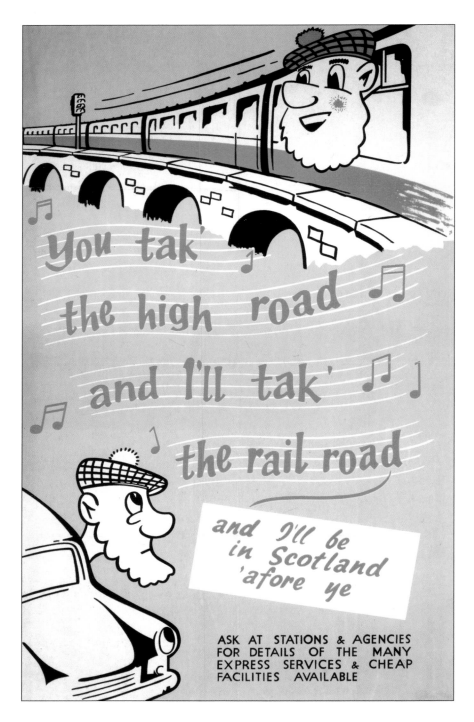

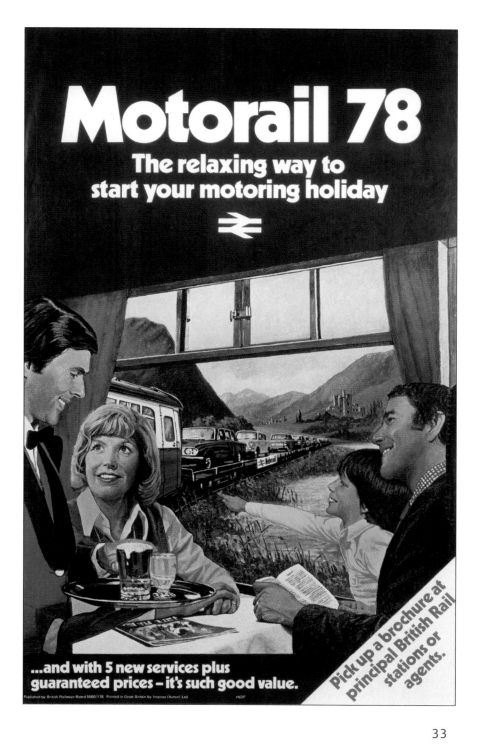

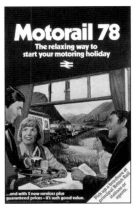

Page 32: 'You tak' the high road and I'll tak' the rail road'

Anonymous, 1960s

This humorous cartoon-style poster makes an interesting comparison with the 1914 East Coast Route Stage Coach poster on page 15. This is a typical example of British Railways fighting the growing use of car travel in the 1960s.

Photography by National Museums Scotland
© NRM Pictorial Collection/Science & Society Picture Library

Page 33: Motorail 78

Anonymous, 1978

The practice of carrying cars on trains was not new when British Railways launched their Motorail brand in 1966. This poster promotes a more relaxing way to start a holiday when compared with a lengthy car journey.

The service went as far as Fort William and Inverness. Motorail ended in 1995 just prior to rail privatisation.

Photography by National Museums Scotland
© NRM Pictorial Collection/Science & Society Picture Library

Opposite: Make the perfect escape to the Scottish Highlands and Islands

Anonymous, 1978

This pictorial map seems to suggest that the journey to Scotland is perhaps not so lengthy. Although the image shows the whole of Great Britain, England is squeezed into a narrow band across the bottom, with more space to illustrate the sights north of the border.

Photography by National Museums Scotland
© NRM Pictorial Collection/Science & Society Picture Library

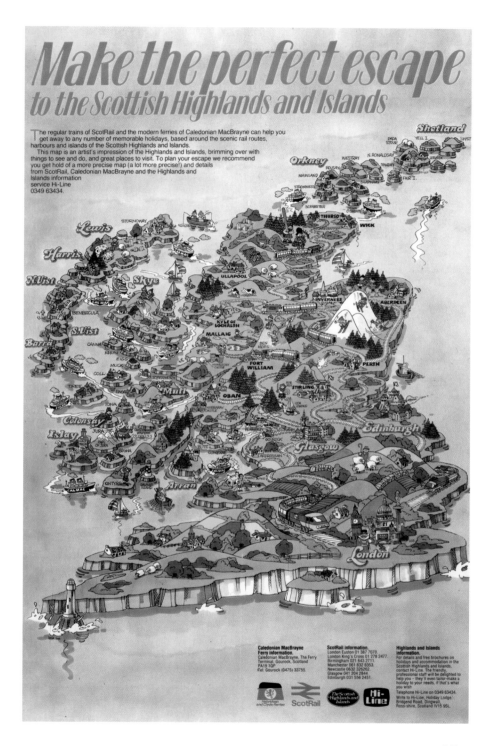

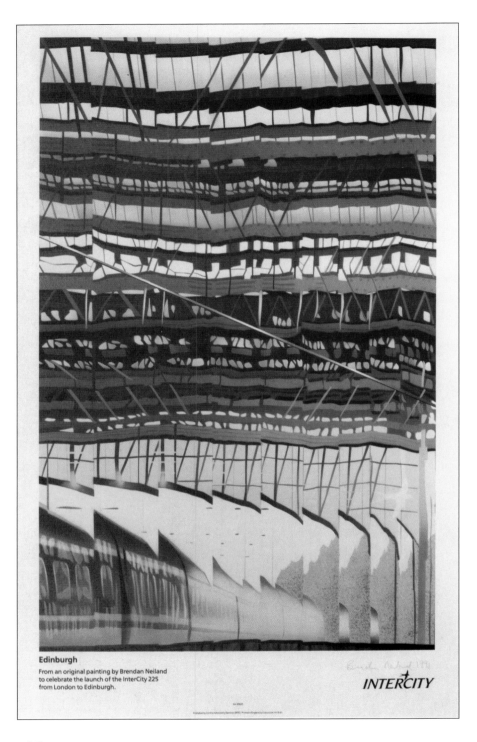

Edinburgh

From an original painting by Brendan Neiland
to celebrate the launch of the InterCity 225
from London to Edinburgh.

INTERCITY

36

InterCity

In 1965 British Railways became British Rail and the brand of Inter-City was created for its long distance high-speed services. The first advertising campaign in 1967 featured the popular Monica who appeared on posters, travelling to meet friends.

In 1991 the East Coast route was electrified and new InterCity 225 trains were introduced. The brand ceased to exist when the railways were privatised in the 1990s.

Opposite: Waverley station

Brendan Neiland, 1991

This is the finished poster issued by InterCity in 1991 to celebrate the electrification of the East Coast main line and the introduction of the new IC225 fleet of trains. This poster has been signed by the artist.

Photography by National Museums Scotland
© NRM Pictorial Collection/Science & Society Picture Library

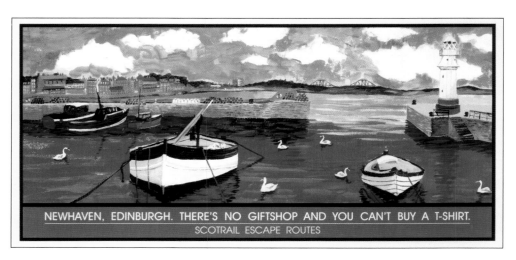

NEWHAVEN, EDINBURGH. THERE'S NO GIFTSHOP AND YOU CAN'T BUY A T-SHIRT.
SCOTRAIL ESCAPE ROUTES

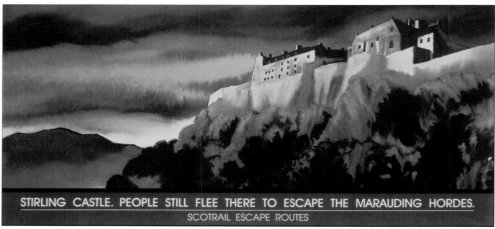

STIRLING CASTLE. PEOPLE STILL FLEE THERE TO ESCAPE THE MARAUDING HORDES.
SCOTRAIL ESCAPE ROUTES

Opposite, above: Newhaven, Edinburgh

Anonymous, 1996

This poster is one of four from the ScotRail Escape Routes series. It illustrates the small fishing harbour on the edge of Edinburgh. The nearby railway station at Trinity closed to passengers in 1925 and the nearest is now in the city centre.

© NRM Pictorial Collection/Science & Society Picture Library

Opposite and detail below: Stirling Castle

Anonymous, 1996

This striking image of Stirling Castle is another poster from the Escape Routes series. The marketing campaign was produced by ScotRail in the year before privatisation and featured clever slogans.

© NRM Pictorial Collection/Science & Society Picture Library

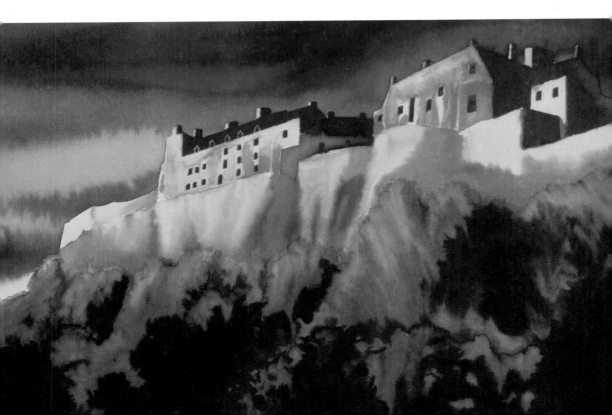

Privatisation
and the Modern Age

In the period from 1994 to 1997, British Rail was broken up and privatised. For services within Scotland there was to be one franchise company, ScotRail, operated by National Express. Some of the long distance companies – such as GNER, Virgin and Cross Country – cross the border and run services as far north as Inverness.

Today GNER has been replaced by East Coast and the ScotRail brand is operated by the First Group. Many of the posters produced today manage to present changing information and the latest special offers, while still using attractive artwork.

Opposite: Train leaving Ladybank Junction, Fife, 2002

John Burnett, photographer

This Edinburgh to Aberdeen train is travelling on a line originally opened in 1847, when it connected Burntisland to Cupar. The line on the left was opened in 1848 and meets the Glasgow to Perth line at Hilton Junction. The opening of the second Tay Bridge in 1887 and the Forth Bridge in 1890 altered the pattern of rail services in Fife. From that time, trains were able to run directly between Edinburgh and the north.

National Museums Scotland

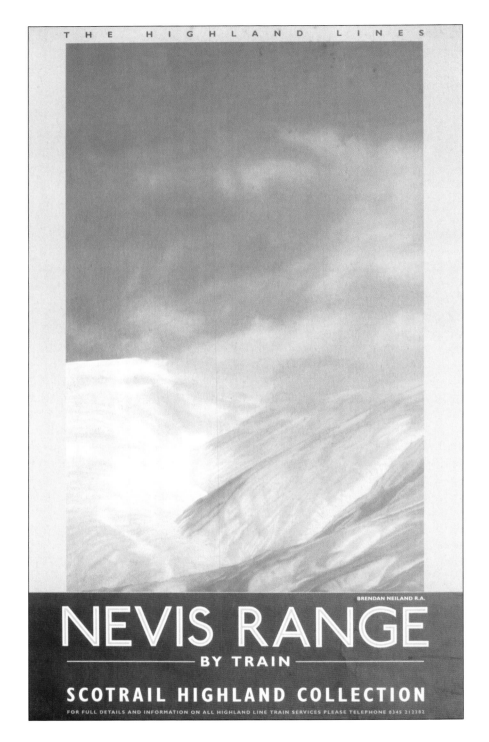

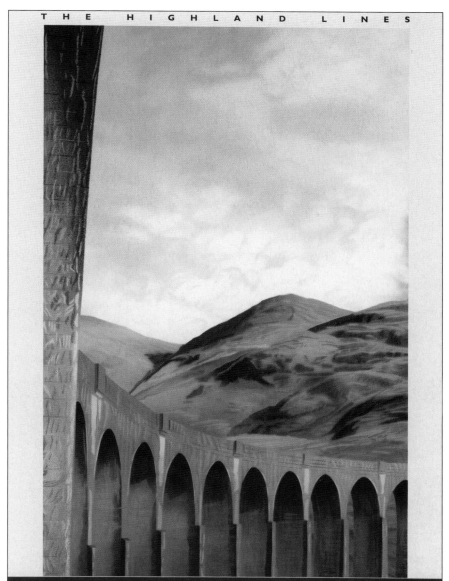

THE HIGHLAND LINES

BRENDAN NEILAND R.A.

GLENFINNAN

BY TRAIN

SCOTRAIL HIGHLAND COLLECTION

Page 42: Nevis Range

Brendan Neiland, 1996

This is one of a series of posters that revived the tradition of commissioning artworks from well known artists, in this case Brendan Neiland who had previously produced work for InterCity. These were the last to be produced before privatisation.

National Museums Scotland
Image © Brendan Neiland

Page 43: Glenfinnan

Brendan Neiland, 1996

Another of the ScotRail Highland Collection posters promoting travel on the Highland Lines in the year before ScotRail was privatised. All the locations are accessible by train, though for the Skye location the railway terminates on the mainland at Kyle of Lochalsh.

National Museums Scotland
Image © Brendan Neiland

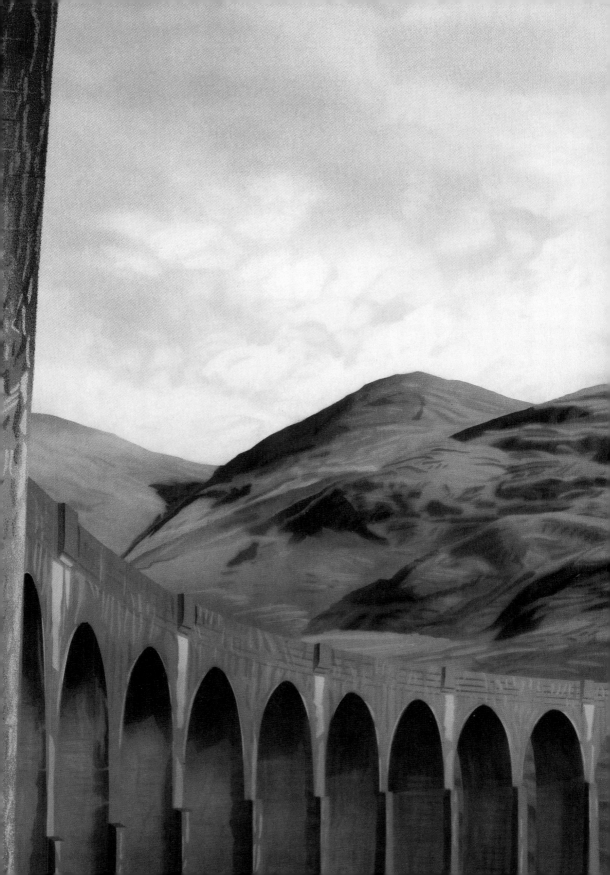

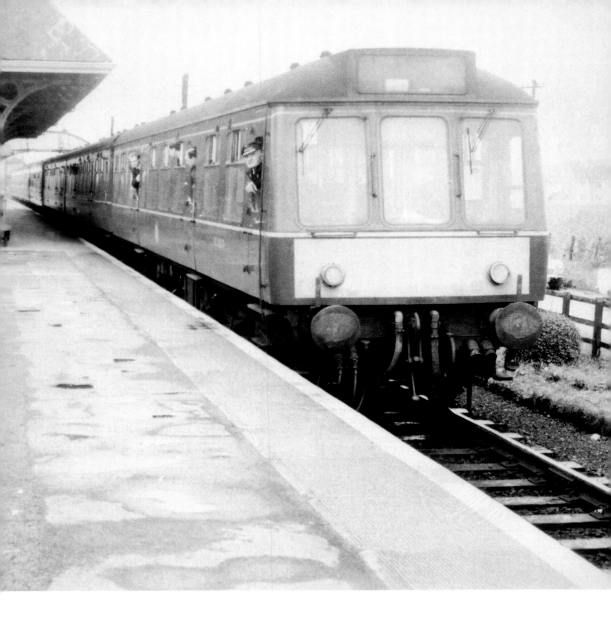

Leuchars station, Fife, 1978

Unknown, 1978

A train at Leuchars station. The station originally opened in 1847, as part of the Edinburgh and Northern Railway's route from Burntisland to Tayport. The train here has manually-operated carriage doors, now considered potentially dangerous to passengers.

National Museums Scotland

46

ScotRail

In 1984 British Rail introduced a new brand ScotRail for all services operated in Scotland. Trains were painted with light blue stripes that harked back to the regional colour used by British Railways in 1948.

British Rail was gradually privatised in the 1990s. The first franchise holder in Scotland was National Express in 1997 who introduced a new logo. They were succeeded in 2004 by First Group and another change of brand. To prevent further style changes, in 2008 the name 'ScotRail: Scotland's Railway' was introduced by the Scottish Government as the name of the whole Scottish rail network regardless of the franchise holder.

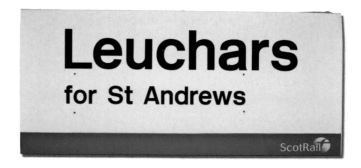

Leuchars station sign, 2005

National Museums Scotland

TURNBERRY LIGHTHOUSE
& AILSA CRAIG, AYRSHIRE

FIRST SCOTRAIL COLLECTION BY CHRIS CLOSE

FIRTH OF FORTH RAIL BRIDGE
FIFE & LOTHIANS

FIRST SCOTRAIL COLLECTION BY CHRIS CLOSE

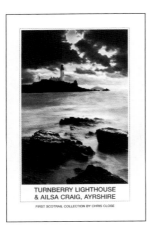

TURNBERRY LIGHTHOUSE
& AILSA CRAIG, AYRSHIRE

FIRST SCOTRAIL COLLECTION BY CHRIS CLOSE

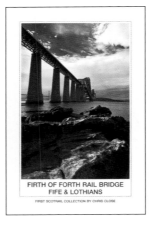

FIRTH OF FORTH RAIL BRIDGE
FIFE & LOTHIANS

FIRST SCOTRAIL COLLECTION BY CHRIS CLOSE

Page 48: Turnberry Lighthouse & Ailsa Craig, Ayrshire

Chris Close, 2006

After taking over the ScotRail franchise from National Express in 2004, First Group commissioned Chris Close to take a series of dramatic photographs for their posters. This one features the lighthouse at Turnberry, with the Ailsa Craig rock in the background.

National Museums Scotland
Image © Chris Close Photography

Page 49 and detail opposite: Firth of Forth Rail Bridge Fife and Lothians

Chris Close, 2006

This poster uses another dramatic image from the series commissioned from photographer Chris Close and shows the rail and road bridges across the Firth of Forth.

National Museums Scotland
Image © Chris Close Photography

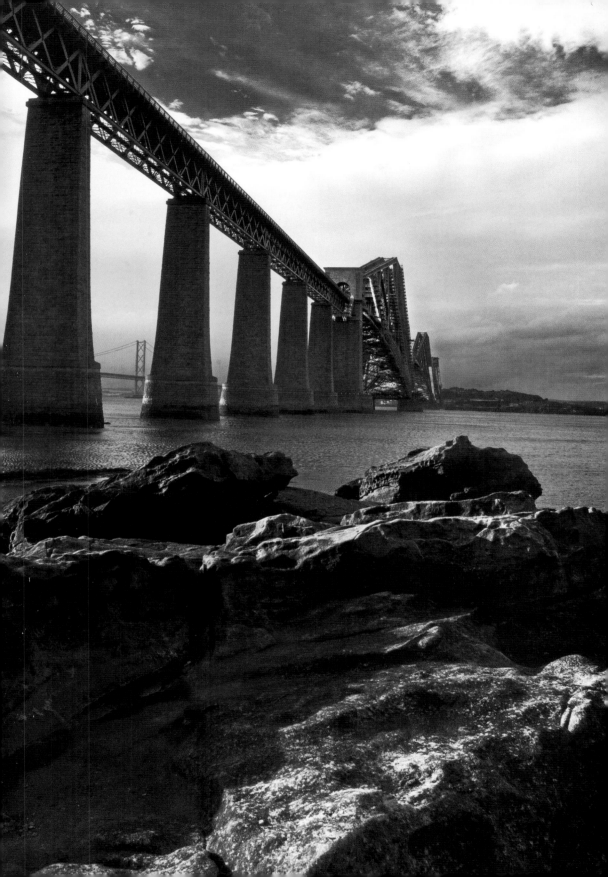

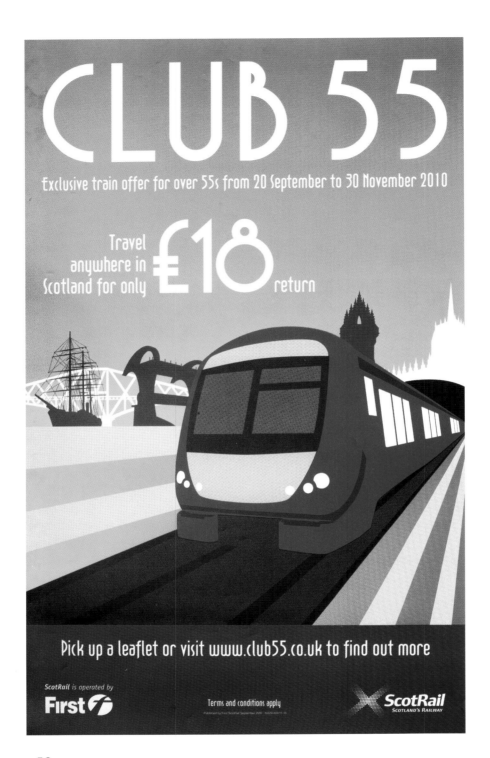

London's just a sleep away

C A L E D O N I A N **S L E E P E R**

scotrail.co.uk/sleeper

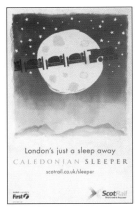

Page 52: ScotRail Club 55

Anonymous, 2010

This recent poster promoting cheap travel for people over 55 uses an Art Deco style that harks back to the 1930s. The iconic landmarks shown here are the Forth Bridge, SS *Discovery*, Falkirk Wheel, Wallace Monument and Marischal College in Aberdeen.

National Museums Scotland

Page 53: Caledonian Sleeper

Anonymous, 2010

This Art Deco style poster looks back to the golden age of travel and the overnight sleeper trains that are still a feature of the railway today. The Caledonian Sleeper is now operated by ScotRail from London Euston to Edinburgh, Glasgow, Aberdeen, Inverness and Fort William six nights a week.

National Museums Scotland

Opposite: Little Angels travel free

Anonymous, 2011

One of a series of posters from the current ScotRail franchise holder First Group. Each in the series is aimed at a particular group of passengers, in this case families.

National Museums Scotland

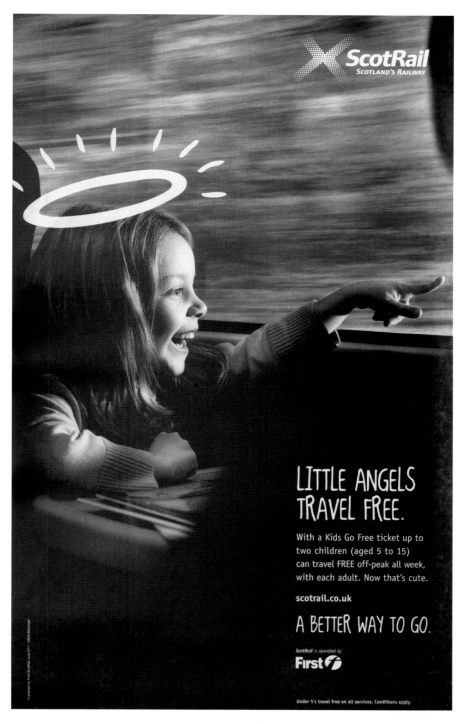

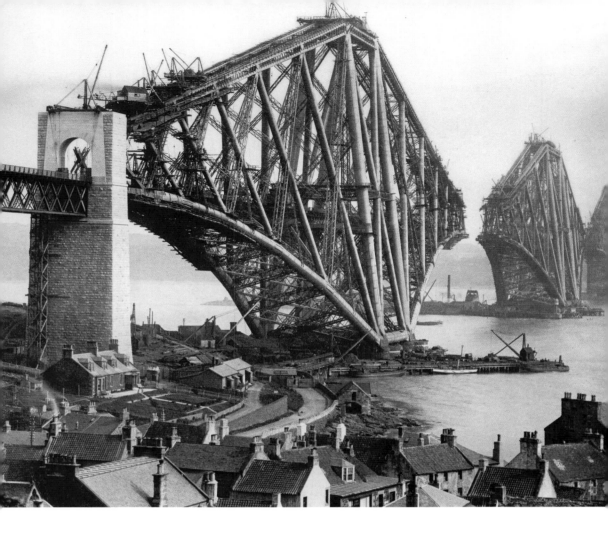

Above: The construction of the Forth Bridge from the North Queensferry side

Photographer unknown

This photograph was taken in the late 19th century, showing the latter stages of the construction of the cantilevers of the bridge. Workmen on the Fife and Queensferry cantilevers raced each other to become the first to reach the Inchgarvie cantilever in the middle.

National Museums Scotland

Opposite: Forth Rail Bridge from South Queensferry, 1986

Photographer unknown

National Museums Scotland

The Forth Bridge

The Forth Bridge opened in 1890 and has become an iconic structure that now symbolises Scotland and its railways throughout the world. The bridge replaced a ferry crossing from Granton to Burntisland and is a vital link in the rail network connecting Edinburgh with Fife and the north.

Instantly recognisable, the Forth Bridge has long been a popular subject in posters advertising travel by the successive companies whose routes cross the bridge. From the North British Railway that built the bridge to ScotRail today, the magnificent red structure has been used to advertise rail travel in Scotland.

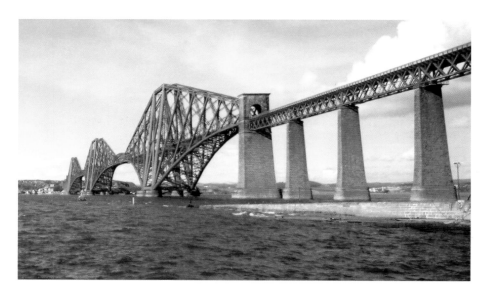

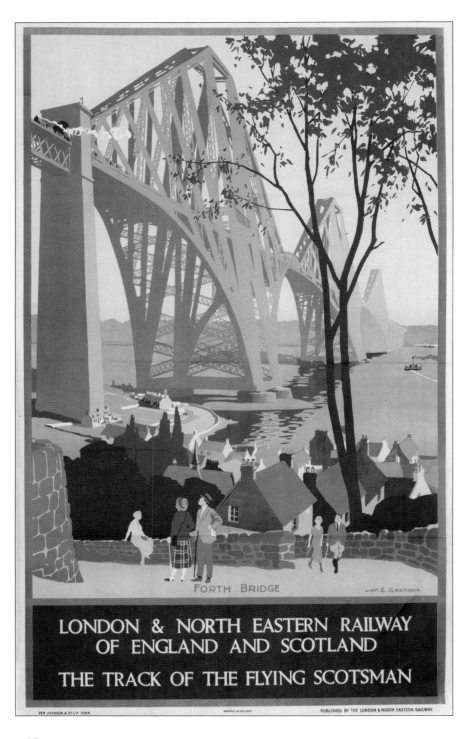

FORTH BRIDGE

LONDON & NORTH EASTERN RAILWAY
OF ENGLAND AND SCOTLAND

THE TRACK OF THE FLYING SCOTSMAN

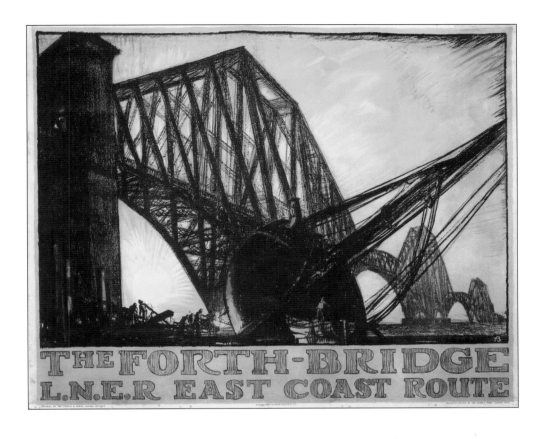

Opposite: The Track of the Flying Scotsman

H. G. Gawthorn, 1928

Photography by National Museums Scotland
© NRM Pictorial Collection/Science & Society Picture Library

Above: The Forth-Bridge L.N.E.R. East Coast Route

Frank Bragnwyn, 1930

Photography by National Museums Scotland
© NRM Pictorial Collection/Science & Society Picture Library

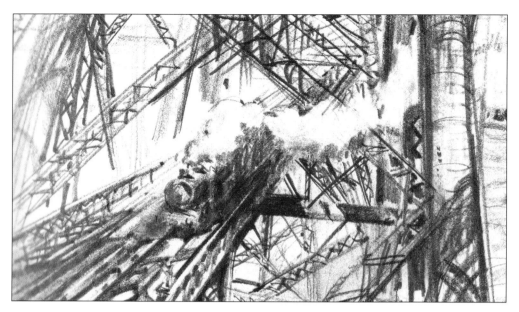

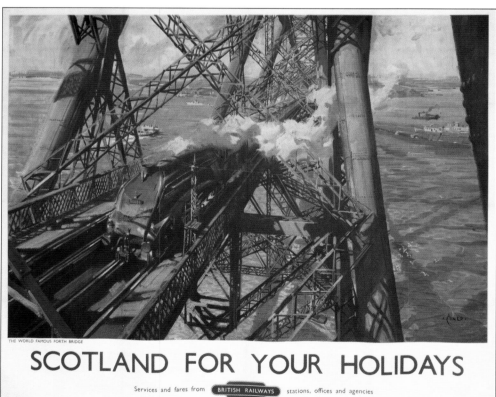

THE WORLD FAMOUS FORTH BRIDGE

SCOTLAND FOR YOUR HOLIDAYS

Services and fares from **BRITISH RAILWAYS** stations, offices and agencies

Cuneo on the Forth Bridge

Terence Cuneo was already well known as a poster artist when he was asked by British Railways to paint an image of the Forth Bridge for a new poster. The date was 6 February 1952 and the weather was terrible. Cuneo had to climb up the bridge structure dressed in long woollen underwear, a flying suit and a duffle coat to find the ideal position to make his sketch, as trains passed below him.

Several times he was nearly blown off the bridge in the 85 kmph (53 mph) wind, and his hands became so cold he could hardly hold the pencil. Cuneo returned to the bridge twice more in later years to paint different scenes. On his last visit he painted the *Flying Scotsman* locomotive.

Opposite, above: Original sketch for Scotland for your Holidays

Terence Cuneo, 1952

Courtesy of Carole Cuneo

Below: The finished poster of Scotland for your Holidays

Terence Cuneo, 1952

Photography by National Museums Scotland
© NRM Pictorial Collection/Science & Society Picture Library

About the Artists

Frank William Brangwyn

(1867–1956)

Brangwyn was born in Bruges in 1867, though the family returned to London in 1874. He travelled extensively and many of his best known paintings were painted abroad. He also designed stained-glass windows and furniture, and some of the interior of the SS *Empress of Britain* liner. Although never formally trained, Brangwyn had his work accepted by the Royal Academy. His early railway posters were notable for their dark appearance and limited use of pallet.

Christopher Clark

(1875–1942)

This London artist was self-taught and best known for the historical subjects that he painted, including the Napoleonic and Crimean Wars. Clark was also a gifted book illustrator. He produced a number of posters for both the LNER and LMS railways, many of which featured the pageantry of Britain. When British Railways was created in 1948, six years after he died, a number of his posters were re-issued.

Henry George Gawthorn

(1879–1941)

Born in Northampton, Gawthorn initially trained as an architect. He went on to become an accomplished painter and prominent poster artist. Many of his bright holiday posters have become synonymous with happy holidays in the period just before the Second World War. He often included himself in his posters.

Brian de Grineau

(1882–1957)

Best known as a motoring artist, de Grineau produced some notable railway posters. Although he did not receive any academic training, he studied under his father Charles who was a well-known illustrator and caricaturist. De Grineau's distinctive style creates a feeling of speed and movement in cars and locomotives.

Montague Birrell Black

(1884–1964)

Born in Stockwell, London, in 1884 and educated at Stockwell College, Black became a celebrated poster artist and illustrator. He was war correspondent for the *Toronto Star* during the Second World War and did naval artwork. He was also an artist for the White Star shipping line. Black was especially well known for the map posters he created for many of the railway companies, including LMS and LNER.

John Edmund Mace

(1889–1952)

Mace was a well-respected artist who was appointed as official war artist in France in 1918. He exhibited at the Royal Academy and produced many fine landscape and marine paintings. Like many other artists, he created paintings for all four of the grouped railway companies after 1923 for use as posters.

Terence Tenison Cuneo

(1907–1996)

Cuneo produced some of the best known railway posters, including iconic images of the Forth and Tay bridges. He studied at the Chelsea and Slade Art Schools and became an accomplished portrait painter and a painter of technical subjects. Cuneo was the official painter to Queen Elizabeth for the Coronation in 1953. His trademark mouse appeared in all his posters from 1953 onwards.

Brendan Neiland

(1941–)

Neiland studied at Birmingham and then the Royal College of Art, London. He was elected as a Fellow of the Royal Society of Arts in 1996 and became a Professor at the University of Brighton. His paintings are in a very distinctive style and he produced posters for British Railways and their InterCity brand. Neiland has exhibited extensively and is still producing new work.

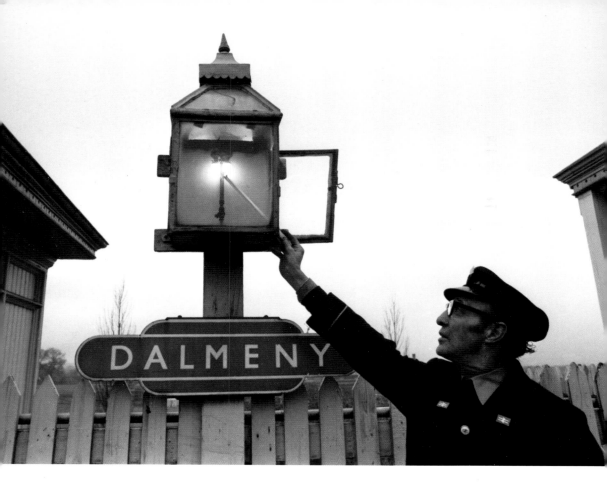

Dalmeny station gas lamps, 1978

Crauford Tait, photographer

As late as 1978, Dalmeny railway station, at the south end of the Forth Bridge, still had functioning gas lamps. Here, one of the railway staff has the task of lighting the lamps.